CURATOR'S CHOICE
L.S. LOWRY
THE LOWRY
COLLECTION

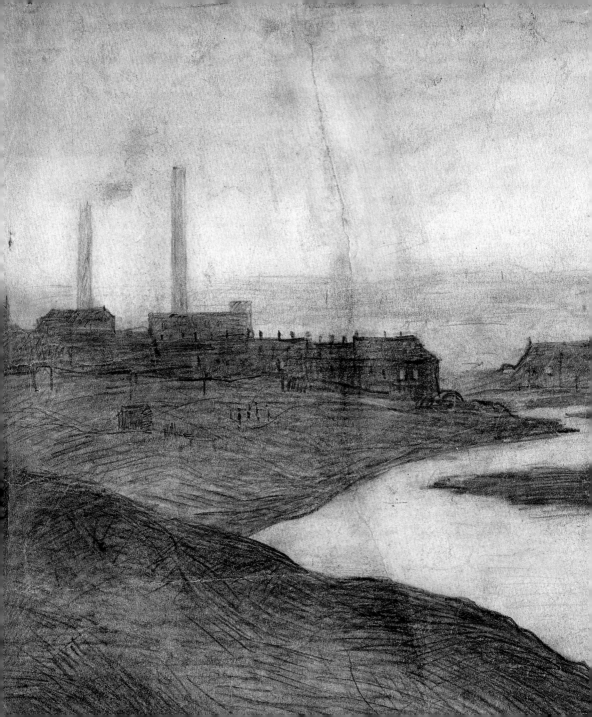

L.S. LOWRY
THE LOWRY COLLECTION

Claire H. Stewart

SCALA

INTRODUCTION

Laurence Stephen Lowry has long been one of Britain's most popular artists. He is known for his industrial landscapes and crowd scenes but they were only one facet of his broader vision which included evocative seascapes, rural views and imagined portraits. As the world's largest collection of paintings and drawings by the artist, The Lowry Collection provides unrivalled insight into L.S. Lowry's art. The Collection is unique in its variety of subject matter and in representing all periods of Lowry's career.

Today, Lowry's works can be found in many galleries and museums, but Salford Art Gallery (now Salford Museum and Art Gallery) followed his career most consistently, purchasing its first work by the artist in 1936. In 1951 the Gallery held a retrospective of Lowry's work and purchased 13 of his pictures. Lowry had a close relationship with the Gallery as both a visitor and an artist and donated a further 14, creating the core of the collection as it stands today. The Lowry Collection now numbers around 400 works of art alongside an extensive archive of photographs, press cuttings and exhibition catalogues that provide a rounded view of Lowry's career.

Once the third busiest port in the country, Salford Docks were closed in 1982 and became part of a major redevelopment with a landmark, multi-disciplinary arts centre at its heart. Despite having lived there for only part of his life Lowry had become closely associated with Salford, and The Lowry was named after him when it opened in 2000 as one of the Heritage Lottery Fund's Millennium Projects. At the heart of The Lowry's work is a commitment to its local communities and young people and it is now home to The Lowry Collection.

For most of his life Lowry combined painting with full-time employment as a rent collector and clerk. Although he was exhibiting regularly by the 1920s it was not until he was 52 that he had his first solo London exhibition at the Lefevre Gallery and gradually began to profit from the sale of his paintings. 'I didn't resent having to wait that long', he later said, 'No one ever asked me to paint. They didn't owe me anything'.

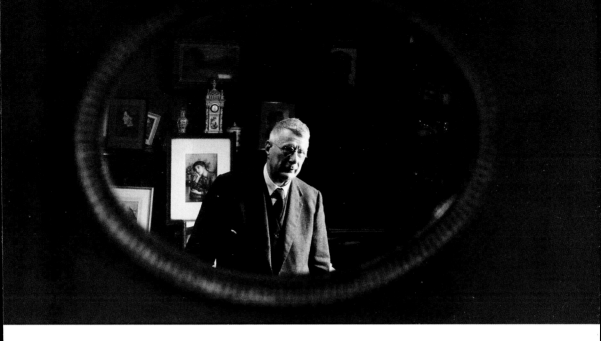

L.S. Lowry at his home, The Elms, in Mottram-in-Longdendale.

By the 1960s Lowry, now retired, was becoming a household name. He was elected a member of the Royal Academy in 1962 but refused several official Honours, including an OBE and a Knighthood. Concerned that he would be labelled an amateur if people knew he had never left employment, Lowry crafted an edited biography for himself. However, in trying to control his narrative, it became riddled with inaccuracies even before his death. Common misconceptions held him to be entirely self-taught, a recluse and unconnected to the art world of the time. Although he often described himself as lonely he nonetheless had a wide and diverse circle of friends, many of whom remembered him as an entertaining raconteur and accompanied him to the many cultural pursuits that he enjoyed. For a much-imitated artist so apparently familiar to us, Lowry's life and career remain full of surprises. The Lowry Collection, in its range and variety, provides the broadest context in which to look at his life, work and career afresh.

Laurence Stephen Lowry (1887–1976)

Landscape, 1912

Oil on canvas, 35.5 x 25 cm

Purchased from Alex Reid & Lefevre Ltd in 1959

1959-630

After leaving school, Lowry took painting lessons from two Manchester artists – Reginald Barber (at one time Vice President of the Manchester Academy) and William Fitz. In 1905 he began evening drawing classes at Manchester Municipal School of Art, taught by the French artist Adolphe Valette. Under Valette's influence, Lowry was briefly inspired to paint in an Impressionist style. Later, he was to look back on these student years, saying, 'I cannot over-estimate the effect on me at that time of the coming into this drab city of Adolphe Valette, full of the French Impressionists, aware of everything that was going on in Paris. He had a freshness and breadth of experience that exhilarated his students'.

Landscape shows Lowry experimenting with this Impressionist approach. His paint is applied in small dabs, particularly in the foliage of the trees, but there is little sense of his using colour to create changing effects of light. Although Lowry claimed that he did not paint outdoors after 1910, it is likely that this canvas was painted on the spot. James Fitton, a younger student and friend of Lowry's, recalled going out with him to make 'vaguely Impressionist studies at Heaton Park … Boggart Hole Clough or Northenden'.

Although Lowry admired the Impressionists as 'wonderful pioneers' he went on to say, 'I am not very much in sympathy with them'. He did not see in their work what he liked to refer to as the 'battle of life'. For Lowry the work of Honoré Daumier, best known for his lithographs satirising nineteenth-century French politics and society, was more in tune with his own.

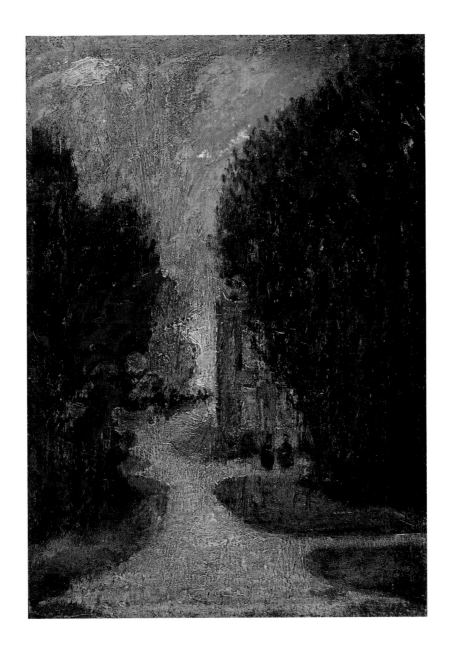

LAURENCE STEPHEN LOWRY (1887–1976)

Seated Male Nude, c.1914

Pencil on paper, 54.8 x 34.9 cm

Presented by the artist in 1952

1952-57

WHEN LOWRY ENROLLED AT Manchester Municipal School of Art to attend evening classes his training followed a very traditional route: 'I took Preparatory Antique, Light and Shade, and then, after a time, the Antique Class, and when they thought I was sufficiently advanced in Antique I went into the Life Class'. This drawing is inscribed by the artist 'LS Lowry 8 hrs' (the time it took to complete the drawing). Lowry was honest about his skill in the drawing class, recognising that he was not the best student: 'I did not draw the life really well. I was competent'.

After leaving Manchester art school Lowry continued classes at Salford School of Art for many years. This was partly because he enjoyed the company of other students but also because he believed that 'long years of drawing the figure is the only thing that matters'. Although his own figure style was to become very personal and stylised, life drawing was nonetheless the foundation for it: 'If you can draw the life, you can draw anything'. One of his chief frustrations in later life was that many people thought he was untrained, saying to him, '"You're self-taught aren't you?" I'm sick of it … I did the life drawing for twelve solid years'.

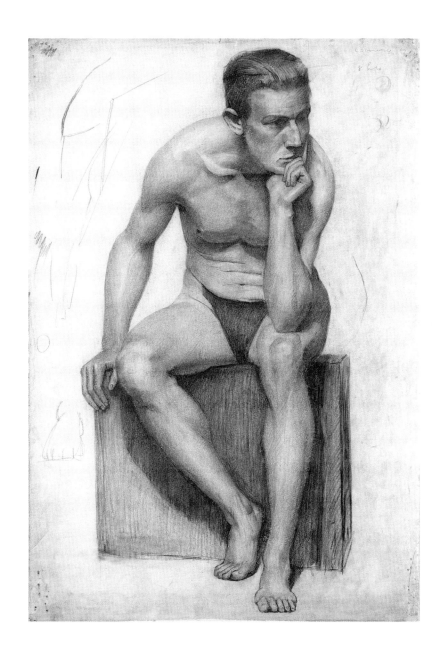

PIERRE ADOLPHE VALETTE (1876–1942)

Drawing from the Antique (Germanicus), undated

Charcoal on paper, 60.7 x 45.5 cm

Donated in memory of the late David Marshall in 2004

AA2004-1

THIS DRAWING IS THE only work in The Lowry Collection not by L.S. Lowry himself. It is unique in showing the work of Lowry's teacher alongside identical subject matter by his pupil (see inset). When Adolphe Valette first arrived in Manchester in 1904 he had enrolled as a student at Manchester Municipal School of Art, but his skill as a draughtsman was swiftly recognised and he was invited to apply for the post of Master of Painting and Drawing. One of the classes he taught was the evening life drawing session which Lowry was to attend.

Born in Saint-Etienne and trained in Lyon and Bordeaux, Valette was a charismatic teacher. At the time, he had a profound influence on Lowry, who recalled: 'he gave me the feeling that life drawing was a very wonderful thing ... I had not seen drawings like these before ... and they helped me very much. They were great stimulants'.

Valette worked alongside his students, correcting and commenting on their sketches. As well as teaching, he undertook commercial design work for the textile trade in Manchester and continued to advance his own career as an artist, exhibiting locally and in Liverpool. Before Lowry chose industrial scenes as his principal subject matter, Valette had also found inspiration in the urban landscape of the city, creating numerous oil sketches and atmospheric larger-scale paintings of the canals, bridges and railway lines sitting alongside Manchester's grand civic buildings. A number of these works are in Manchester Art Gallery's collection and are the paintings for which he is best known today.

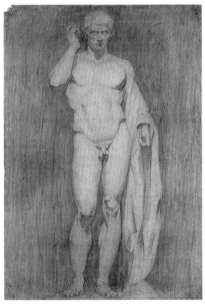

LAURENCE STEPHEN LOWRY
(1887–1976)
Nude from the Antique, c.1911
Pencil on paper, 54.2 x 35 cm
Purchased from the artist in 1961
1961–9

The casts of antique sculptures at the art school in Manchester enabled students to study the effects of light and shade in order to render the human body realistically in three dimensions.

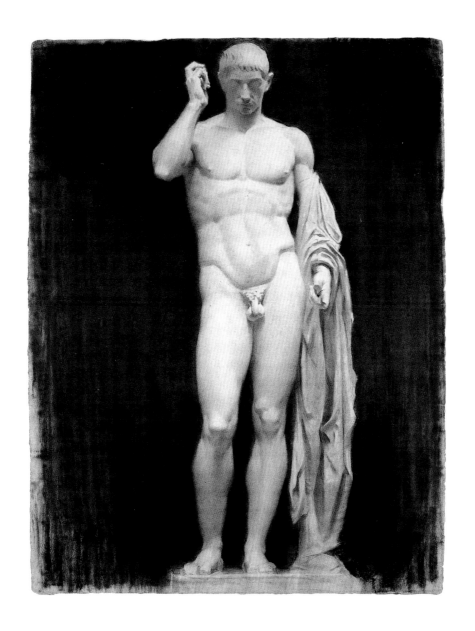

UNKNOWN PHOTOGRAPHER

Costume Class, Salford School of Art, 1920s

Black and white photographic print, 18 x 24 cm

PH30-1999-1

IN 1915 LOWRY ENROLLED at Salford School of Art. In this photograph of a costume class he is seen standing to the left of the model, hand on hip. The Lowry Collection archive also holds an annotated print naming some of the other students present, including Fred Makin (behind Lowry), C.J. Lamb (seated between them), and Ada Jones (seated third from the left). Jones often accompanied Lowry on sketching trips and they corresponded until the late 1940s. She is one of several women suggested as having provided inspiration for 'Ann' – the enigmatic subject of several portraits by Lowry.

One of the tutors at the art school was Bernard D. Taylor, art critic for the *Manchester Guardian* (see p. 16). His sympathetic review of Lowry's work in the newspaper was greatly appreciated by the artist but it was his comments on Lowry's technique that were to change his painting fundamentally:

> I showed him one or two pieces I had done of crowds in the street in front of an industrial scene and they were very confused; with the ground and the figures getting rather mixed up together. So he said, 'This will never do … Can't you paint the figures on a light ground?' I was very annoyed … but I went home and I did two pictures of dark figures on an absolutely white ground … I showed these to him and he said, 'That's what I meant. That's right.'

This white ground was to remain the basis of Lowry's oil paintings going forward and contributes to the distinctive, recognisable character of his work today.

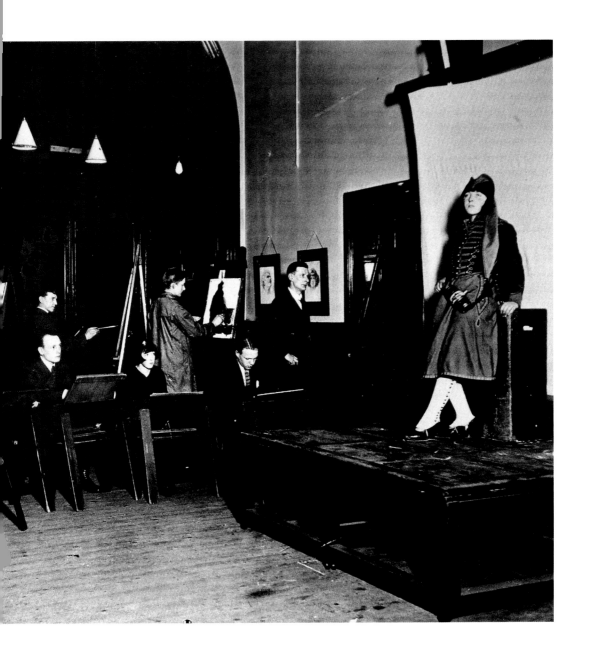

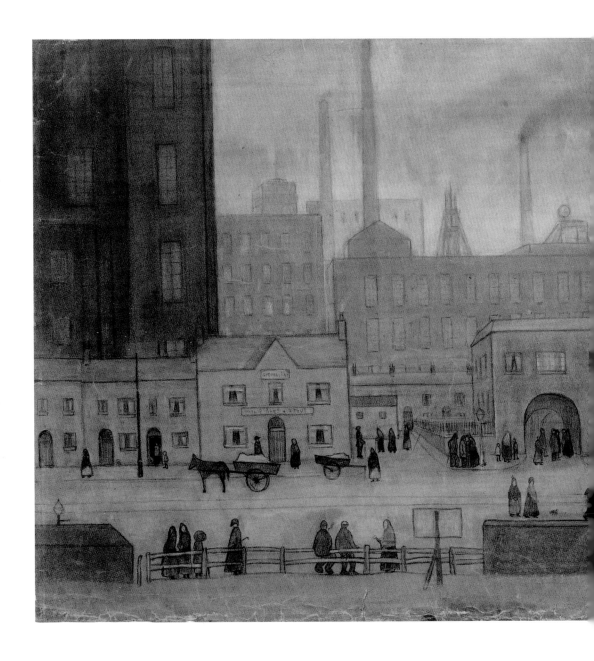

Laurence Stephen Lowry (1887–1976)

Coming from the Mill, c.1917–18

Pastel on paper, 43.7 x 56.1 cm
Presented by the artist in 1958
1958-4

This pastel drawing is one of Lowry's earliest composite industrial scenes and it provided the basis for his oil painting of the same subject in 1930 (see pp. 40–1). Although Lowry made drawings wherever he was, sketching on scraps of paper or the back of private view invitation cards and bank statements, many of these small sketches were quick visual notes purely for his own reference. They were not necessarily worked up at home into larger drawings that could be exhibited or turned into paintings. Later composite landscapes were often developed on the canvas as he went along, without any prior drawing: 'I used to start in the morning in front of a big white canvas, and I'd say: "I don't know what I'm going to do with you, but by the evening I'll have something on you."'

This pastel version of the scene is an ambitious composition, slightly larger in size than the oil painting that followed it. The pastel colours have faded slightly but, even allowing for that, the pale, almost moonlit tones create a quite different colour scheme from the painting. Pastel was not a medium Lowry used very often: 'You can't get weight in pastels. I could never get weight … Pastel is too fluid. Pastel is a thing you can play about with and you can't with oil'. Presumably he deemed it a successful work as he retained the drawing for 40 years before donating it to Salford Art Gallery.

LAURENCE STEPHEN LOWRY (1887–1976)

The Lodging House, 1921

Pastel on paper, 50.1 x 32.6 cm

Bequeathed by Mr G.H. Aldred in 1963

1963·44

ONE OF LOWRY'S EARLIEST exhibitions in Manchester was at the city centre offices of an architect, Rowland Thomasson, in the autumn of 1921. He exhibited eight works, including *The Lodging House*, alongside pictures (mostly watercolours) by Thomasson himself and Thomas H. Brown. None of Lowry's works sold but shortly afterwards *The Lodging House* was to become, he said, his first sale: 'It was to a friend of my father's … He gave me £5 for it'. It seems likely that this buyer was Thomas Aldred, for whom Lowry had previously worked, as the bequest of the picture to Salford Art Gallery years later came from one of Thomas's relatives. Aldred probably saw the work in the exhibition and purchased it later.

The exhibition was reviewed in two Manchester newspapers. For the writer from *Manchester City News* Lowry showed 'prosaic subjects presented in a rather daring and certainly unusual fashion'. The *Manchester Guardian* review was written by Bernard D. Taylor, one of Lowry's tutors at Salford School of Art, and the artist always looked back on it with pleasure and appreciation:

> Mr Laurence S Lowry has a very interesting and individual outlook. His subjects are Manchester and Lancashire street scenes, interpreted with technical means as yet imperfect, but with real imagination. His portrait of Lancashire is more grimly like than a caricature, because it is done with the intimacy of affection … The artist's technique is not yet equal to his ideas. If he can learn to express himself with ease and style and at the same time preserve his singleness of outlook he may make a real contribution to art.

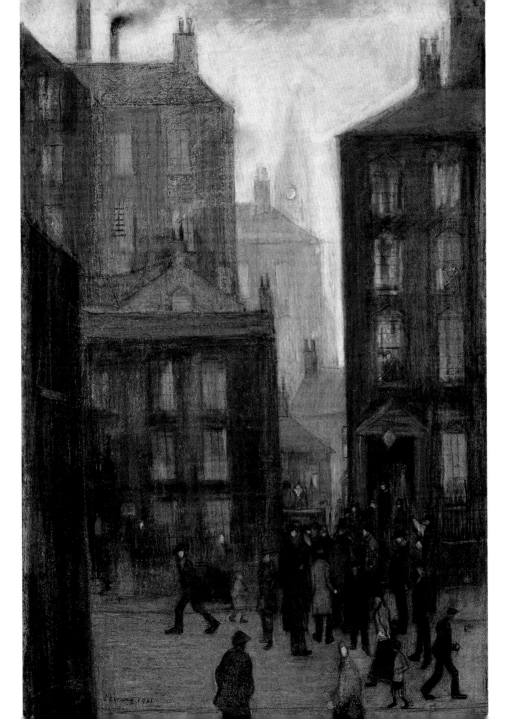

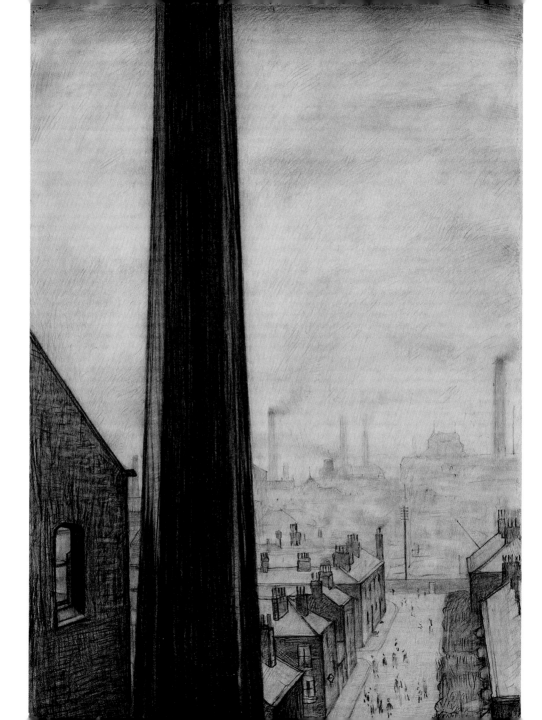

LAURENCE STEPHEN LOWRY (1887–1976)

View from a Window of the Royal Technical College, Salford, 1924

Pencil on paper, 54.4 x 37.5 cm

Presented by the artist in 1951

1951·17

THIS VIEW, FROM A balcony of the Royal Technical College (now the Peel Building of the University of Salford), looks towards the centre of Salford. It is one of Lowry's boldest compositions. Instead of a distant array of mill chimneys along the horizon, one huge chimney in the foreground dominates and partly blocks the view, running from top to bottom of Lowry's paper. The terraced houses below and the figures in the street seem tiny by comparison. Unlike his views from the other side of the building that show Peel Park, this drawing demonstrates how closely the city's industry and housing encroached on the parkland, and how valuable an open green space it was for Salford's residents.

Lowry uses an array of different techniques in his drawing to create the effects he wants, using the HB (or even softer 5B and 6B) pencils he preferred. In working over areas such as the chimney these soft graphite pencils created a rich, velvety sheen:

> I'm immensely fond of pencil. I like pencil to hang up in my house. I think there's something wonderful about a pencil drawing. I just draw, and rub it with my finger or anything else, and then fiddle with it – I think 'fiddle with it' is the right term – until I get it right.

LAURENCE STEPHEN LOWRY (1887–1976)

View from a Window of the Royal Technical College, Salford, looking towards Manchester, 1924

Black chalk and pencil on paper, 55.5 x 37.5 cm

Purchased from the artist in 1952

1952-37

While a soft graphite pencil was probably Lowry's favourite medium, he also used chalk, particularly in some of the life drawings he completed during the evening classes at art school. This work, a companion to his view from the balcony of the Technical College looking towards Salford (see p. 18), is more loosely drawn in chalk than its pair. There is one small pencil addition – the tiny dog walking along the terrace with the other park visitors.

The view towards Manchester shows a far more open aspect, taking in a glimpse of the trees in Peel Park. The building on the right is the rear of Salford Art Gallery, running alongside the statue-lined terrace located above the park at this date. In the distance, beyond the River Irwell, are the factories on its banks and the spire of St Simon's Church. The two drawings give a monumental quality, not only to the grand civic architecture of the art gallery, but to the dense rows of domestic terraced houses and the mills beyond, where most of their residents worked.

Over the course of his life Lowry travelled widely throughout the United Kingdom (although he never went abroad) but Salford retained a place at the core of much of his work. He was later to encourage young artists to remain close to their roots rather than automatically assume a move to London was necessary: 'No need to go to London to become a famous painter. You won't find better lamp-posts there'.

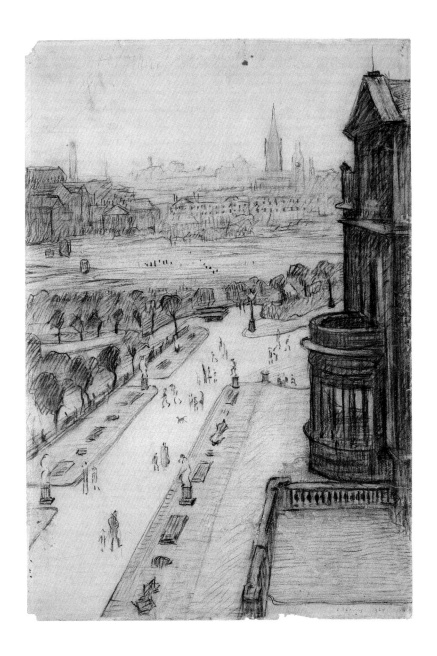

Laurence Stephen Lowry (1887–1976)

The River Irwell at the Adelphi, 1924

Pencil on paper, 35.5 x 52.3 cm
Presented by the artist in 1958
1958-5

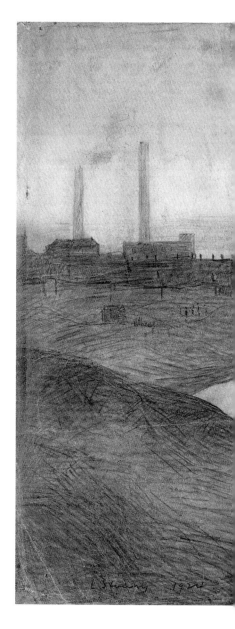

The River Irwell winds through Salford, forming the boundary between the city and its neighbour, Manchester. The stretch of the river running through the Adelphi district, and alongside Peel Park, was distinctive for its particularly wide bend. This drawing dates from the same year as Lowry's views from the Royal Technical College windows (see pp. 18–21) and is another example of his close and repeated study of this area.

The Irwell was slow moving, polluted and often flooded in the winter. In the late nineteenth century it was described as being 'almost proverbial for the foulness of its waters; receiving the refuse of cotton factories, coal mines, print works, bleach works, dye works, chemical works, paper works, almost every kind of industry'.

Lowry's view shows the water level rising to meet the buildings which crowd both banks and the air seems heavy with smog and damp. The factories are at work, chimneys smoking, but there is no sign of life outside, nor any hint of the large green space of Peel Park nearby. In the distance the view opens out to the vast, spreading city, including the recognisable spire of St Paul's Church and, in the far distance, Kersal Ridge. Lowry made several studies of the river at this location and it became a key visual reference for the flooded, stagnant pools of water which appear in many of his industrial panoramas including *The Lake* (see pp. 48–9).

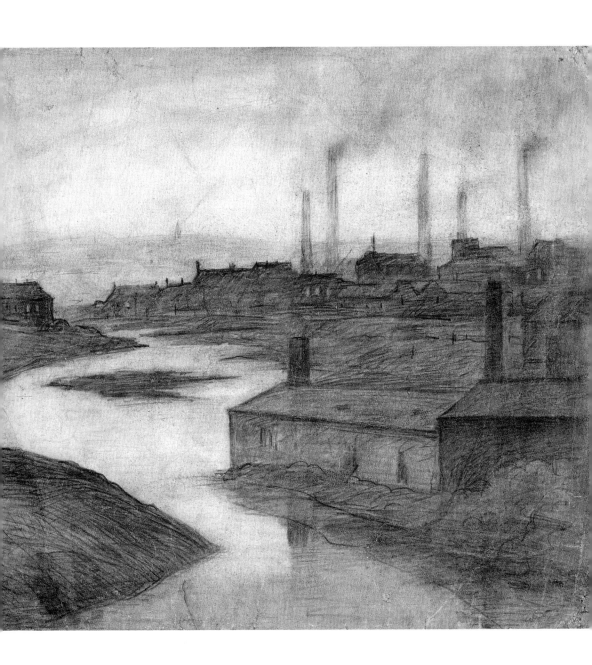

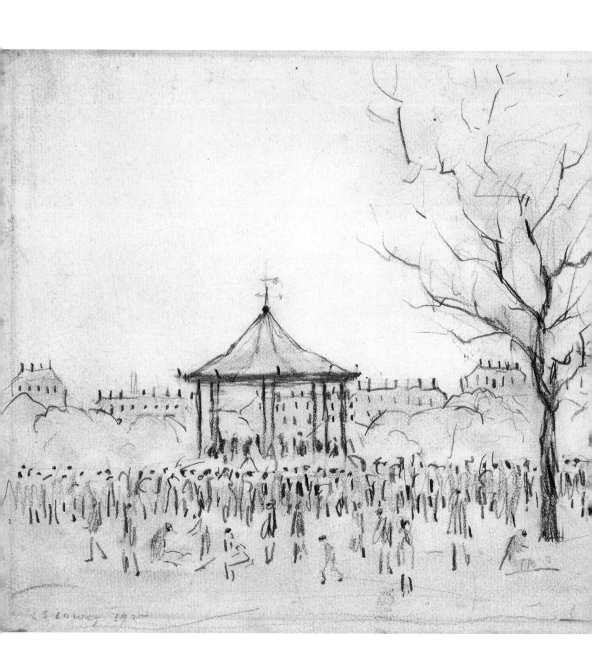

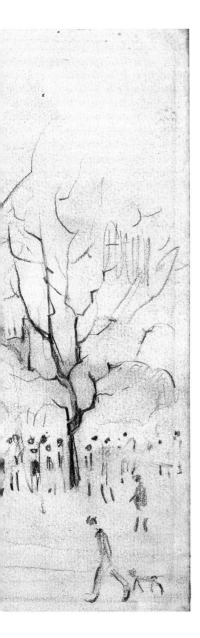

Laurence Stephen Lowry (1887–1976)

Bandstand, Peel Park, Salford, 1924

Pencil on paper, 17.1 x 24.5 cm

Purchased from the artist in 1952

1952-34

THE BANDSTAND IN PEEL Park was built in 1902 but demolished in 1965. In contrast to the bird's-eye view of his detailed drawing made the following year (see pp. 26–7), in this work Lowry has moved down into the park and become one of the bystanders himself (albeit further removed from the action than even the man walking his dog who enters the picture on the right – head down, ignoring the crowd and the music altogether). From this viewpoint Lowry looks through the bandstand and beyond to Lark Hill Mansion (demolished in 1936), the Museum and Library as well as the other buildings along the Crescent now hidden by the more recent developments which form part of the University of Salford.

The day is cold and wintry and Lowry makes as much of a feature of the bare spiky tree branches as he does of the bandstand itself, its pointed roof echoing their shape and balancing out his composition. Despite the cold, a crowd has gathered to listen to the band. Their heads are a repeated pattern of quick dots and strokes, made with a soft graphite pencil, and their forms are largely rendered by a speedily repeated series of vertical lines. By now Lowry's figure style had moved closer to the shorthand rendition more familiar today and away from the harder, outline characters of his early drawings: 'I was very worried at first. Because when I drew from life they looked alive, and when I drew them out of my head they didn't'. He quickly realised, however, that 'had I drawn them as they are, it would not have looked like a vision. It would have been anybody's view of Manchester'.

Laurence Stephen Lowry (1887–1976)

Bandstand, Peel Park, Salford, 1925

Pencil on paper, 36.7 x 54.6 cm

Presented by the artist in 1951

1951-16

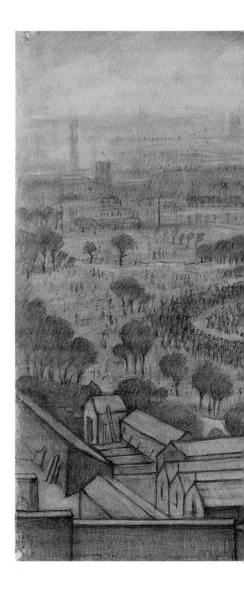

Lowry loved watching people – at fairgrounds, football matches, busy markets or in the park. More interested in the rhythmic patterns formed by the crowd than the individuals within it, Lowry's figures ebb and flow in groups, each carefully positioned to lead the viewer's eye into the composition, but seeming to move naturally.

Salford's largest green space, Peel Park, was a focal point for the city's residents, particularly on Sundays and holidays. 'From the start I have been very fond of this view and have put it in many paintings. You know that I never paint on the spot, but look for a long time, make drawings and think'.

Lowry drew almost every aspect of the park but the bandstand in particular appealed to him as a focal point where crowds gathered. The high viewpoint in this drawing, again sketched from a window of the Royal Technical College, allows the extent of the park to spread out before the viewer. In the foreground are the greenhouses, in the distance the sprawling smoky city, but in this moment almost everyone we see has their full attention on the music. On the outer edges of the circle people come and go, pausing for a moment to watch and listen. The crowd gradually becomes thicker, but forms an orderly line around the dancers, caught up in the music, and at the centre is the tiny figure of the conductor, arms aloft, enthusiastically leading the band.

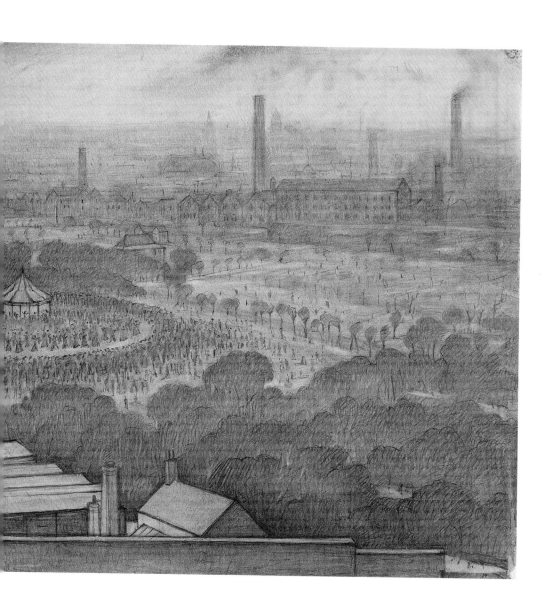

Laurence Stephen Lowry (1887–1976)

Self Portrait, 1925

Oil on plywood, 56.9 x 47.1 cm

Purchased from Alex Reid & Lefevre in 1959

1959·635

Painted when the artist was 37 years old Lowry later recalled: 'I had a great tussle with it, and when it was done I said, "Never again, thank you." I think it was very good when I did it'. This work seems to be the only occasion on which Lowry attempted a realistic likeness in a self portrait. Later works are more abstract in concept – explorations of the artist's state of mind at the time, rather than representations of a physical likeness. Lowry depicts himself not as a romantic artist but as a down-to-earth northern man. He gazes at the viewer with something of the direct challenge of those later portraits but in this case his gaze also derives from the practicalities of viewing himself in a mirror for the purposes of the portrait.

He was to look back on this period, from the mid-1920s until his father's death in 1932, as one of his happiest. Although very few of his works sold at this time, he was exhibiting regularly, including in Paris, and this decade was probably his most prolific. When Robert Lowry died in 1932 he left debts which his son gradually paid off. Lowry's mother, Elizabeth, retired to her room after Robert's death, remaining 'bedfast' until she herself died seven years later.

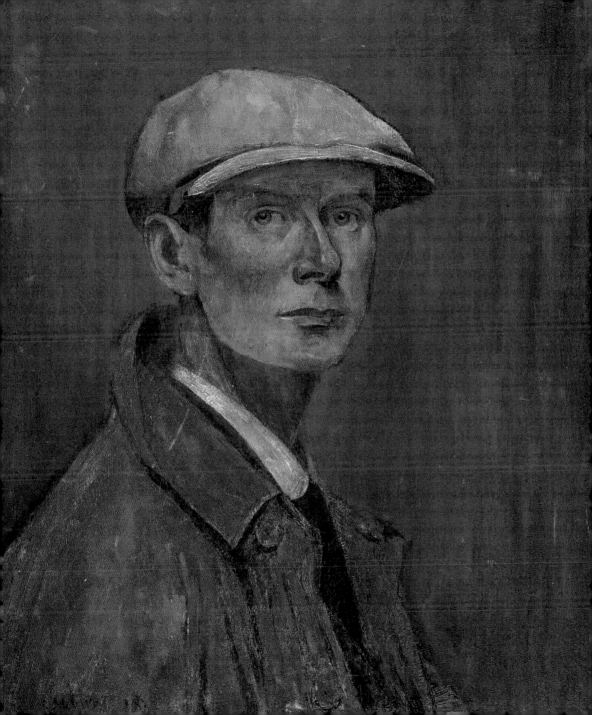

Laurence Stephen Lowry (1887–1976)

The Flat Iron Market, c.1925

Charcoal, pencil and white chalk on grey paper; 28.3 x 38.3 cm
Presented by the artist in 1951
1951-19

The Flat Iron Market was held on a triangular area of land, surrounded by three different streets, which gave the location its name. Although the market closed in 1939, Sacred Trinity Church, at the centre, still stands. Known for selling second-hand clothing, some of the market's covered stalls can be seen huddled in front of the church in Lowry's drawing.

This drawing is unusual for its loose, sketchy style, emphasised by Lowry's use of charcoal, with white chalk for highlights. Although Lowry made rough sketches on the spot, wherever he went, drawings of this size were completed at home in his workroom (he never referred to it as a studio). At the family home on Station Road, Pendlebury, this was in effect an attic room where he painted:

> right on into the early hours of the morning … Light doesn't bother me you see, except for my finishing touches which must be done in daylight. I love working at night when everything is still and peaceful … Often I play the same record over and over again, all through the night … I love monotony you see, as well as music.

The precise ruler-drawn lines which helped to create the architectural backgrounds of many of Lowry's early works have given way here to vibrant, energetic, freehand lines. The scene looks particularly naturalistic and is a convincing depiction of a well-known location. A smattering of people populates the street in the foreground but they are far more shadowy forms than is usual in Lowry's street scenes.

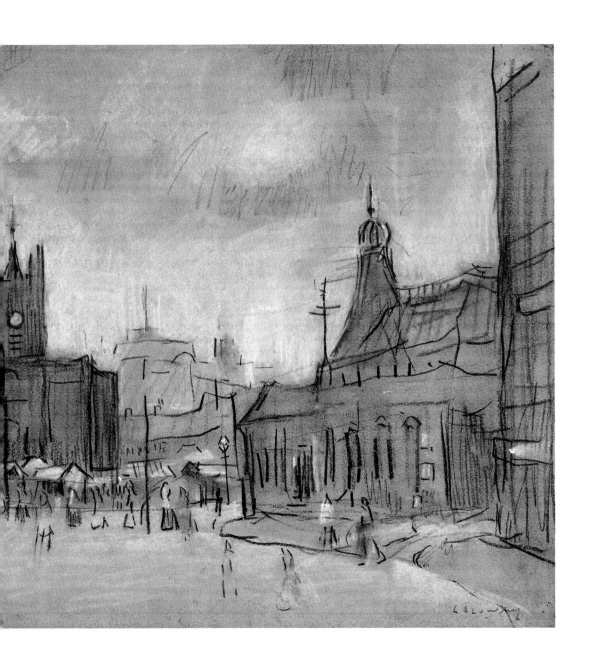

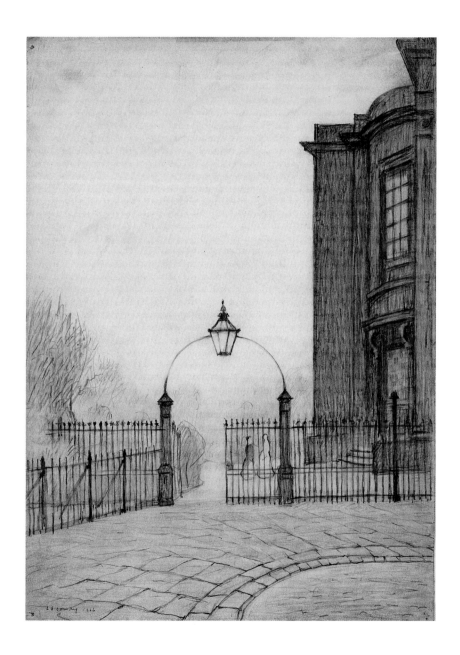

Laurence Stephen Lowry (1887–1976)

By Christ Church, Salford, 1926

Pencil on paper, 35.5 x 25.3 cm

Presented by the artist in 1951

1951-21

Industrial Salford, where terraced houses crowded into every available space between mills, factories and dye works, has now almost entirely disappeared, replaced by modern developments. The industrial areas had attracted Lowry but the city's older, quiet corners (many of which have also now been demolished and redeveloped) held equal appeal for him: 'There were special parts I liked, a bit Georgian, older than the rest'. Lowry made a number of drawings of these areas in the 1920s, including figures that often seem appropriately Georgian in style themselves. In this work they are perfectly framed by the closed half of the gate, an indistinct, misty landscape opening up behind them.

In the 1950s Lowry was to return to some of these areas at the request of Ted Frape, the Curator of Salford Art Gallery at the time, who commissioned him to record parts of Salford where buildings were soon to be demolished and the areas redeveloped. Despite the largely topographical nature of the commission Lowry nonetheless rearranged the views, altering the proportions and scale of buildings and in some instances adding structures that simply did not exist. Many of the relevant sites were close to the Art Gallery, including Christ Church, which was almost directly opposite the entrance to Peel Park. By this time, 30 years after Lowry had first recorded its secluded surroundings, the building was riddled with dry rot and had been declared unsafe. The last service took place on 30 September 1956 and 18 months later the church was demolished.

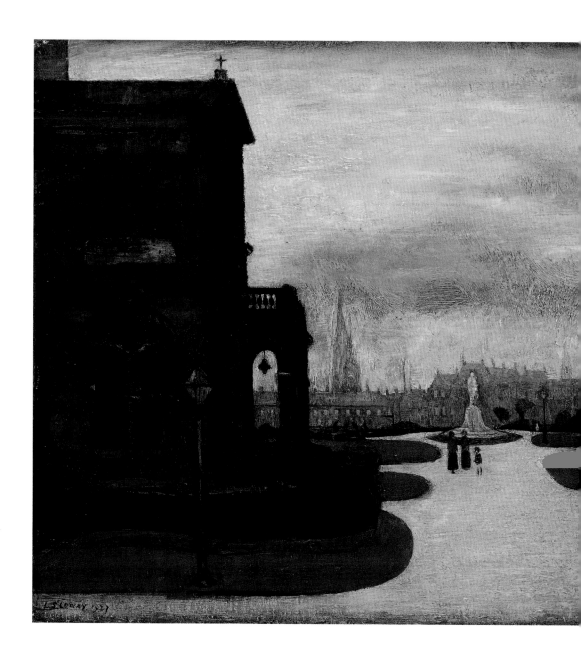

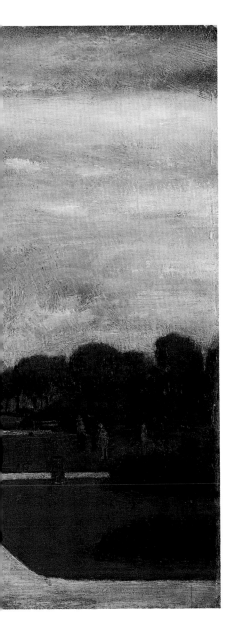

LAURENCE STEPHEN LOWRY (1887–1976)

Peel Park, Salford, 1927

Oil on plywood, 35.5 x 50.5 cm

Purchased from the Mid-day Studios in Manchester in 1951

1951-14

THIS PORTICO ENTRANCE TO Salford's Royal Museum and Public Library (now Salford Museum and Art Gallery) still stands, though the view beyond, including the spires of St Philip's Church and Salford Cathedral, is now blocked off by the modern addition of Salford University's Maxwell Building. Again probably painted from the vantage point of the Royal Technical College, Lowry chose in this case to focus on the art gallery with which he was to have a life-long association. He visited regularly and formed close relationships with its curators over the decades.

Some familiar elements of Lowry paintings are present in this view – including the stylised simplification of the pattern made by the paths and lawns, similar to his later pared-back views of hills and lakes. This early oil has a more traditional Victorian feel in its dark tones and in Lowry's choice of a more conventionally picturesque Salford landmark. The darker tones are characteristic of Lowry's paintings before he switched to preparing his canvases with a pure white ground.

Originally private land around Lark Hill Mansion, Peel Park was named after the Prime Minister, Robert Peel, who in 1788 had been born a few miles away in Bury. Having bought the estate by public subscription in 1846, Salford City Council opened it to the public in 1850. The library was the first unconditionally free municipal library in the country. Lowry's painting shows the 1878 extension to Lark Hill Mansion.

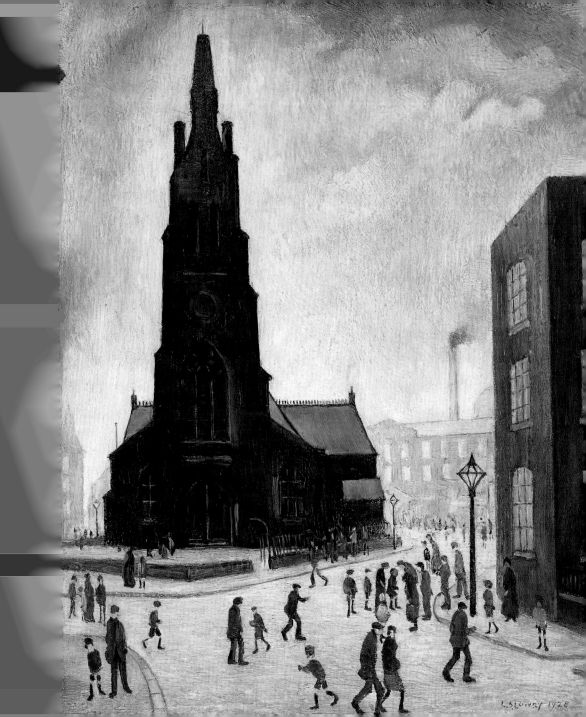

Laurence Stephen Lowry (1887–1976)

A Street Scene (St Simon's Church), 1928

Oil on plywood, 43.8 x 38 cm

Purchased from the Spring Exhibition of the Manchester Academy of Fine Arts in 1936

1936-2

This oil painting was the first work by Lowry to be acquired for Salford Art Gallery's collection. According to Lowry his father, Robert, rarely took an interest in his art. On this occasion, however, knowing that the church was due for demolition, he encouraged his son to make a drawing of it: 'it's your cup of tea and it's going to come down very soon'.

Lowry's first sketch, made on the spot, was scribbled on the back of a torn envelope. It quickly recorded the basic shape of the building, indicating the tall mills framing it on either side, and incorporated the curve of the sealed edge of the envelope into the scene as part of the kerb. When he returned several months later Lowry found that the building had already gone, but he used his tiny initial sketch to produce a larger worked-up drawing, and finally this painting, which retains all the essential elements of Lowry's first impressions. Figures have been added to create a busy foreground, and mill buildings in the background, but the church remains the focus, darkened with pollution and unwelcoming. It is a particularly monochromatic scene, with the artist's trademark touches of red in the figures' clothing providing one of the few accents of colour.

St Simon's was a large church, designed to hold around one thousand people in its congregation when it was built in 1849. It was located in a densely industrialised area of mills and engineering works. Lowry, always attracted to ugly or derelict buildings, emphasises the sense of isolation and neglect that had settled around the church by the 1920s when its spire had already been partly removed for safety reasons and the door appeared firmly closed.

LAURENCE STEPHEN LOWRY (1887–1976)

Oldfield Road Dwellings, 1929

Pencil on paper, 41.2 x 43.8 cm

Presented by the artist in 1957

1957-155

THE OLDFIELD ROAD DWELLINGS, 60 in total, were contained within this unusually shaped structure – round at one end and rectangular at the other – originally built in 1893 to house skilled workers for the Lancashire and Yorkshire Railway Company. A high wall ran around the top of the building, creating a roof yard, and at the back, shown here, residents chatted to their neighbours through the railings. In the late 1950s Lowry was photographed here several times, posed for the press leaning against the railings, sketchbook in hand, chatting to one of the residents.

Like Peel Park, Oldfield Road Dwellings fascinated Lowry: 'I'd stand for hours on this spot … and scores of little kids who hadn't had a wash for weeks would come and stand round me. And there was a niff [unpleasant smell] too.' He went on, 'In the 1920s I did a lot of drawing in Salford … My favourite places were houses built round factories. They just attracted me more than others. I cannot explain it. But all those places I used to draw have come down in the last five years.' Oldfield Road Dwellings was demolished in 1970.

An earlier oil painting of this scene was exhibited in Lowry's first solo London exhibition in 1939, with the title *Dwellings*, and was purchased by the Tate Gallery. Lowry looked back on this exhibition with great affection: 'I sold about sixteen [works]. My God it was dreadful. It nearly gave us all apoplexy at home. Our brains almost weren't powerful enough. The Tate bought one. I got more pleasure out of that first show of mine than out of anything else in art'.

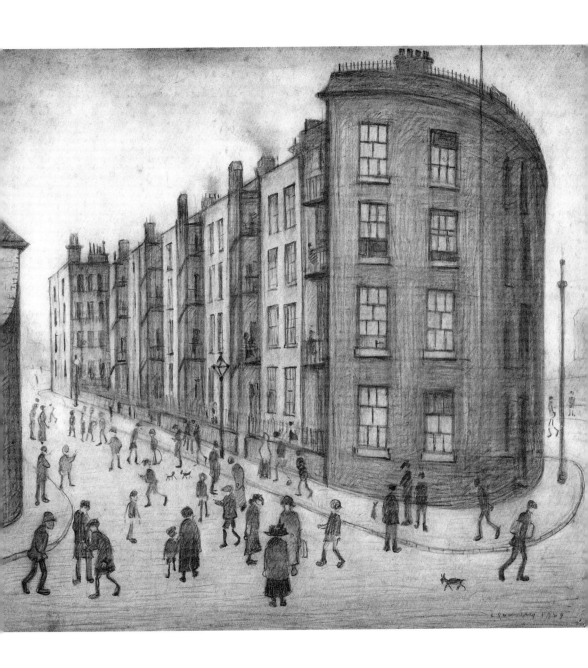

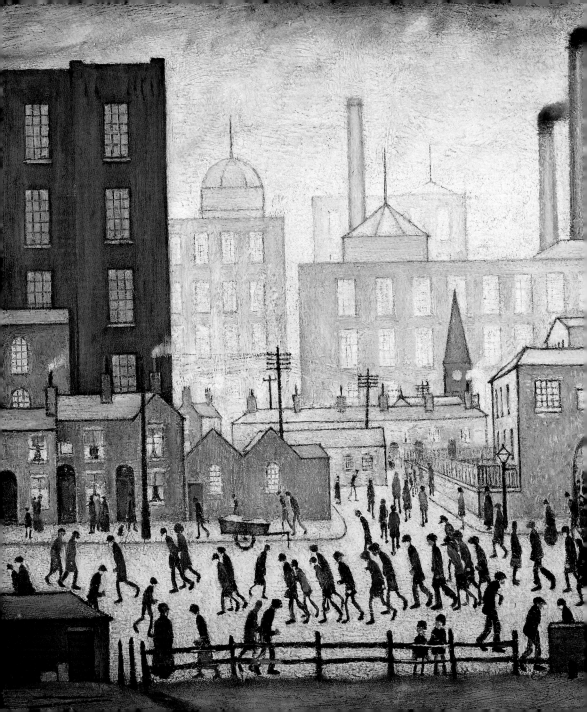

Laurence Stephen Lowry (1887–1976)

Coming from the Mill, 1930

Oil on canvas, 42 x 52 cm

Purchased from the artist in 1941

1941-8

IN A LETTER TO Salford Art Gallery Lowry wrote: 'It gives me great pleasure that Salford have bought this picture – for I have always thought it was my most characteristic mill scene'. The painting had been exhibited in Paris in 1930 and was the third work purchased by the Art Gallery some years later. It was based on his earlier version of the same scene in pastel (see pp. 14–15).

In the 1930s and 1940s Lowry was especially interested in the patterns formed by a crowd. Before 1930 he often included a dramatic incident to provide a focal point, for example in *An Accident* (actually a suicide by drowning) now in Manchester Art Gallery's collection. Here, however, his style has evolved and the rush of people coming out of the mill at the end of a day's work simply dissipates into the casual movement of the busy streets outside. Red highlights on clothes and hats are dotted across the canvas to bind the composition together.

Workers streaming into, or out of, factories or mills have become classic Lowry images. 'I dislike them myself ... yet as soon as I start, what happens? Pitiful-looking people throng around gloomy factories with smoking chimneys. I stare at the blank canvas and that is what I see – and what I have to paint'.

Laurence Stephen Lowry (1887–1976)

St Augustine's Church, Pendlebury, 1930

Pencil on paper, 35.1 x 26 cm
Purchased from the artist in 1952
1952-27

Built in 1874, St Augustine's Church is one of the very few Salford landmarks depicted by Lowry that still stands. Only a short distance from Lowry's home on Station Road, the houses around the church largely belonged to mill workers on low incomes: it was not an affluent parish.

Lowry's drawing focuses almost entirely on the building – a dark, looming presence, dwarfing anyone around it – and almost completely eliminates its tree-lined grassy setting. The small memorial directly in front of the church records the death of 178 people in an explosion at the nearby Clifton Hall Colliery in 1885. Making this even smaller than it is in reality, Lowry emphasises the church's towering scale and adds to this impression by completely excluding a much larger monument in the foreground dedicated to the first vicar of St Augustine's.

Churches recur frequently in Lowry's art, their spires often populating the extended vistas of his composite industrial landscapes. When they feature as the principal subject matter, like St Augustine's or St Simon's (see p. 37), they form an abrupt full stop at the end of a street, usually standing squarely at the centre of the composition. They give no sense of comfort to the viewer. One might reasonably expect Lowry to have portrayed churches as focal points for the crowds that fascinated him, but in his work they are invariably closed, with no one going in or out.

Laurence Stephen Lowry (1887–1976)

A Fight, c.1935

Oil on canvas, 53.2 x 39.5 cm

Purchased from Alex Reid & Lefevre Ltd in 1959

1959-642

Lowry said that he had witnessed this scene outside a lodging house in Manchester. A drawing, titled *Outside a Lodging House* and almost identical in composition, was, like this work, also purchased from the art dealer Lefevre in 1959 for Manchester Art Gallery's collection.

In the 1920s, when he was painting what became known as his 'incident' pictures, Lowry used a fight or an accident as the focal point for a gathering of people within the setting of an industrial landscape. What fascinated him was 'the atmosphere of tension when something has happened … Where there's a quarrel there's always a crowd … it's a great draw. A quarrel or a body'. In this work the incident has been brought to the fore and instead of an extended architectural background Lowry focuses on a close-up view of one particular building.

The fight in this case, however, is less violent than it is entertaining, as one man pulls the other's hat down over his ears while two small dogs square up against each other in sympathy. The sole female bystander looks as though she may simply roll her eyes in weary exasperation before moving on. Although painted more than 20 years later, *Man Lying on a Wall* (see pp. 68–9) is similar in mood to this composition. Some commentators have linked this scene in particular to music hall humour or the films of Charlie Chaplin, both of which would have been familiar to Lowry.

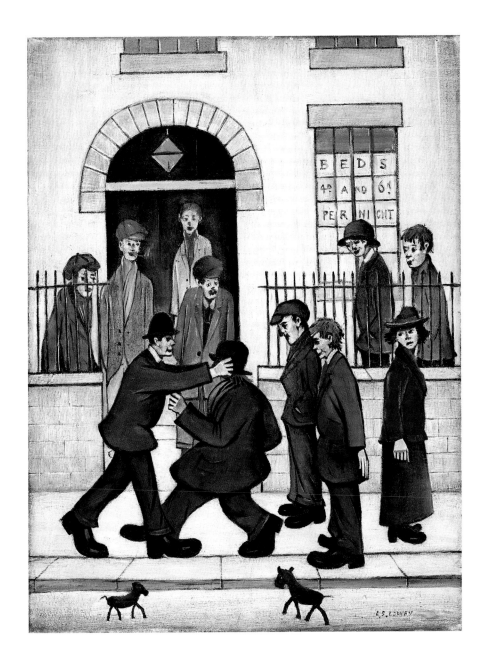

Laurence Stephen Lowry (1887–1976)

A Landmark, 1936

Oil on canvas, 43.4 x 53.6 cm

Purchased from Alex Reid & Lefevre Ltd in 1959

1959-636

Landscape was an important subject in Lowry's work from the start of his career. He was inspired not only by the mills and collieries near his home in Pendlebury, but also the farms and open spaces, such as Swinton Moss, where he walked regularly. Lowry's early drawings of these areas are often more traditionally picturesque than his later landscapes, but his focus on fields and roads stretching into the distance evokes the same feeling of emptiness perceptible in many of his later views. In works such as *A Landmark* the atmosphere is even bleaker. All signs of human activity are removed, though solitary buildings or monuments suggest the former presence of people.

Although Lowry's initial inspiration for these views was often the landscape of Cumbria or Snowdonia, his drawings of even specific locations dating from the 1950s, such as Buttermere or Glencoe, are reduced to minimal, abstracted lines and curves. Distance is hard to judge as forms overlap each other in flat, suspended sections. Lowry's empty landscapes do not record changing effects of light or weather: instead the light is flat and cool, and the fields and hills are reduced to repeated patterns. They are monumental, yet immensely personal views and, like *The Funeral Party* (see pp. 64–5) and Lowry's seascapes, they can convey an atmosphere of suppressed tension. *A Landmark* also carries a strong erotic undercurrent, with its breast-shaped hills and phallic monument.

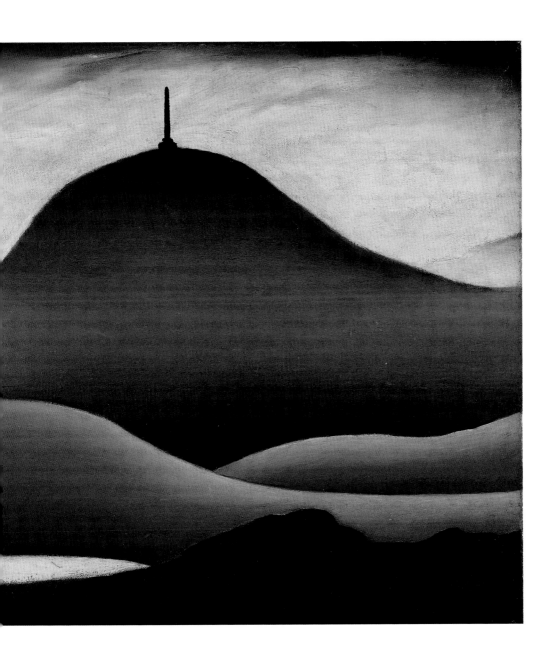

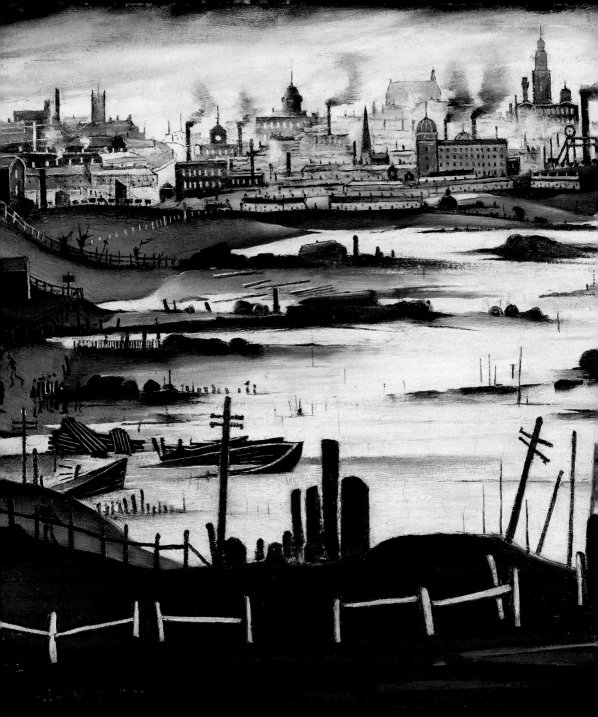

Laurence Stephen Lowry (1887–1976)

The Lake, 1937

Oil on canvas, 43.4 x 53.5 cm

Purchased from Alex Reid & Lefevre Ltd in 1939

1930-19

Lowry was very clear: 'The thing about painting is that there should be no sentiment. No sentiment'. This is particularly true in his apocalyptic vision of the industrial city shown in *The Lake*. Unlike his crowd scenes, where figures fill the streets shopping, going to work or to football matches, the people in this vast imagined, polluted city seem like tiny scavengers on the margins. They huddle in small groups, uncertainly, with the only other sign of life being a small bird perched on a submerged fence post in the middle distance. This is one of Lowry's most desolate and bleak landscapes where a multitude of collieries, church spires and smoking chimneys provide the backdrop to a flooded landscape of stagnant water filled with rotting timbers. Fence posts in the foreground resemble tombstones and this area on the city's outskirts seems to have been abandoned to its fate.

The pool of water derives from the polluted River Irwell, which formed the boundary between Manchester and Salford and frequently flooded. Lowry's job as clerk and rent collector for the Pall Mall Property Company meant that he visited tenants in some of the poorest districts of Manchester and Salford but he was wary of his industrial scenes being viewed as social comment: 'Don't start thinking I was trying to put over some message … I just painted what I saw'.

LAURENCE STEPHEN LOWRY (1887–1976)

Houses in Broughton, 1937

Pencil on paper, 25.3 x 35.6 cm

Purchased from Alex Reid & Lefevre Ltd in 1959

1959-653

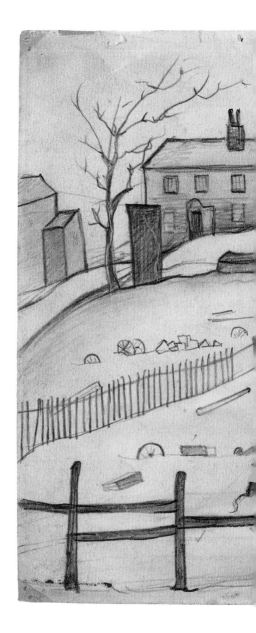

ON A PATCH OF uneven ground in one of Salford's suburbs children pass the time, surrounded by terraced housing, bare winter trees and derelict outhouses. It is hard to tell whether the group on the right are playing a game together or just talking. The two figures on the left keep company with the dogs who are also out on the wasteland. Higher Broughton was one of the areas Lowry visited each week on his rent-collecting rounds.

Lowry was an only child and looked back on his early years as a negative experience: 'I did not enjoy being a child ... It wasn't a nice time at all'. Children feature in many of Lowry's drawings and paintings. They are often the characters most at ease in his compositions and who look directly out at the viewer, drawing us into the scene. When interviewed by his friend Hugh Maitland (who hoped to write a book about Lowry but died before it could be completed) Lowry evidently also saw the 'battle of life' laid out ahead of them: 'Poor little things, they don't know what they have to go through'.

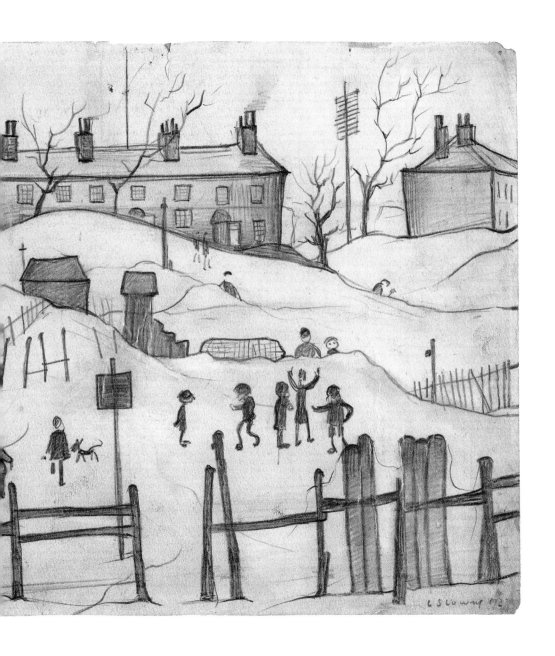

Laurence Stephen Lowry (1887–1976)

Head of a Man, 1938

Oil on canvas, 50.7 x 41 cm

Purchased from Alex Reid & Lefevre Ltd in 1959

1959-637

After the death of his father in 1932, Lowry's mother, Elizabeth, took to her bed as an invalid. For the next seven years Lowry was effectively her principal carer, working at the Pall Mall Property Company during the day and painting late into the night after she had gone to sleep. These were particularly stressful years for him and he told a colleague at Pall Mall that Elizabeth's doctor had recommended he take a break for the sake of his own health. *Head of a Man*, often referred to as 'Man with Red Eyes', was painted at this time:

> It started as a self portrait. I thought, 'What's the use of it? I don't want it and nobody else will.' I turned it into a grotesque head. I'm glad I did it. I like it better than a self portrait. I seemed to want to make it as grotesque as possible. All the paintings of that period were done under stress and tension and they were all based on myself. In all those heads of the late thirties I was trying to make them as grim as possible. I reflected myself in those pictures.

In stark contrast with his *Self Portrait* of 1925 (see p. 29), this is a study in despair that challenges the viewer through the directness of the subject's gaze. The simple blue background is one Lowry used only occasionally. Its starkness helps to emphasise the disturbing character of what is essentially a portrait of the artist's mental and emotional state, rather than his physical appearance.

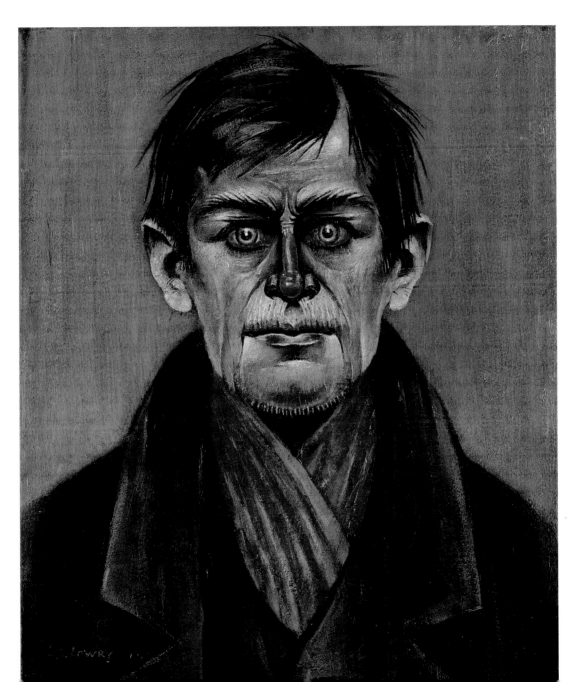

Laurence Stephen Lowry (1887–1976)

Market Scene, Northern Town, 1939

Oil on canvas, 45.7 x 61.1 cm

Presented by the artist in 1942

1942-1

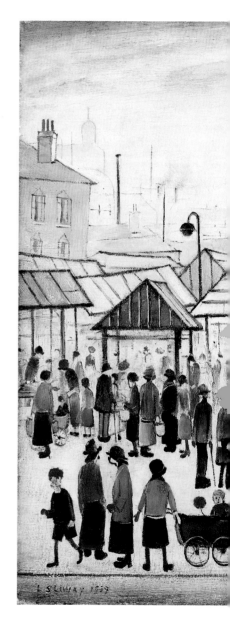

Market Scene, Northern Town is a quintessential Lowry crowd scene showing people at their leisure, rather than travelling to or from work, or bowed into insignificance by an overpowering industrial vista. In a picture filled with incident and activity, the women who make up the majority of the crowd are mainly engaged with the stall holders as they buy or negotiate prices, more so than with each other. Other figures wait their turn or look on while minding prams and young children. Everyone is absorbed in their own activity bar a handful of characters who look from the canvas directly at the viewer.

Lowry's white ground is particularly evident in this work. The architectural background and sky are painted in delicate, cool tones of pink and grey, creating the sense of crisp, fresh morning air, while the darker tones of the stalls and foreground figures anchor the scene in everyday reality. The single line of paint in the foreground, often used by Lowry to denote the edge of a kerb and to distance the viewer a little from the main subject matter of the picture, has one or two figures stepping over it to lead the viewer's eye in. Although it is an invented landscape, the initial inspiration for the scene was Pendlebury Market, close to the artist's home in Station Road.

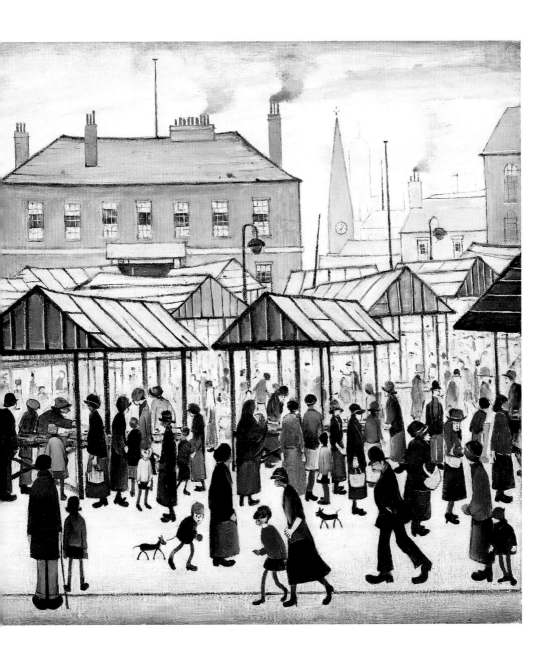

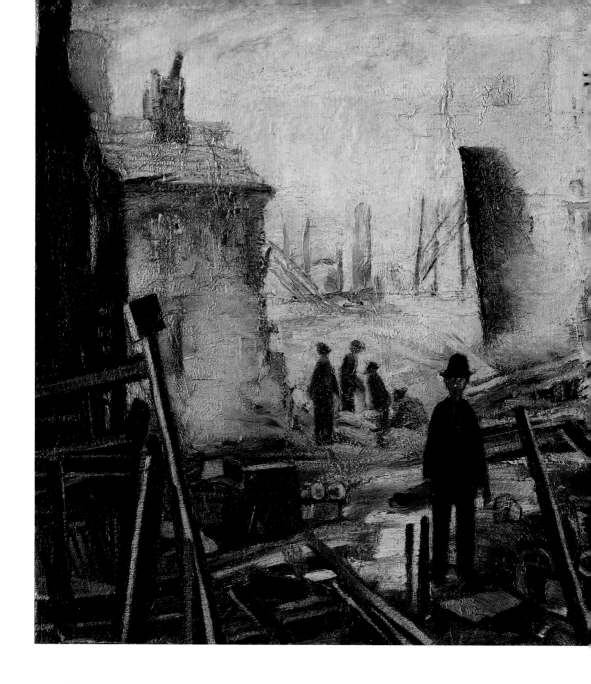

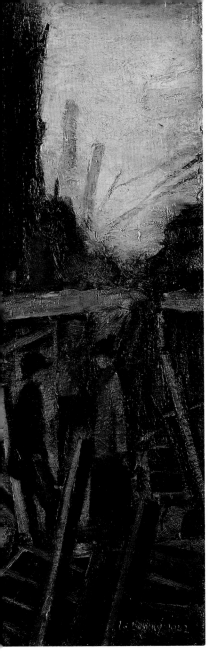

LAURENCE STEPHEN LOWRY (1887–1976)

Blitzed Site, 1942

Oil on canvas, 39.2 x 49.4 cm

Purchased from Alex Reid & Lefevre Ltd in 1959

1959-638

DURING THE SECOND WORLD War Lowry was appointed an Official War Artist by the War Artists' Advisory Committee. He produced very few works in this capacity but several drawings and paintings show the aftermath of bombing raids on Manchester. Lowry took shifts as a fire-watcher, enjoying the solitude of the occupation and the opportunity to be 'first down in the morning to sketch the blitzed buildings before the smoke and grime had cleared'. Some of the drawings he completed appear to be from the vantage point of what used to be the Rylands department store, near Piccadilly Gardens in Manchester city centre.

Blitzed Site may depict damage following the Manchester Blitz in 1941. Lowry gave no clue as to whether it showed a specific location and it probably represents one of very many terraced streets affected. A small group of figures gathers in the middle distance, perhaps to salvage what they can from the wreckage, while one man in the foreground is surrounded by what may well be the remains of his own home, dust and smoke still rising from the ruins.

Of all Lowry's war paintings the best known is *Going to Work*, now in the collection of the Imperial War Museums, which shows the Mather and Platt engineering works in Manchester. Ostensibly a classic Lowry scene of workers heading into a factory, in that painting he also added a wartime barrage balloon high above the parked buses which brought many employees to the works each morning. More subtly, he also arranged the arriving crowd in the shape of a Union Jack.

LAURENCE STEPHEN LOWRY (1887–1976)

Level Crossing, 1946

Oil on canvas, 46.1 x 56.1 cm

Purchased from Alex Reid & Lefevre Ltd in 1959

1959-640

LOWRY MADE SEVERAL SIMILAR paintings and drawings after visiting Burton-on-Trent and seeing the level crossing there. This work may be based on locations in Trafford where a network of lines was established in 1897 to move goods and people around its large industrial estate. Short sections of track still survive today. Although originally designed for gas-powered trams, by the early twentieth century steam locomotives had become the vehicle of choice. However, Lowry also claimed that the locomotive pictured here was drawn from model trains belonging to the son of one of his friends.

The incongruity of a locomotive on the streets may well have been part of the attraction for Lowry, not unlike seeing a man in his business suit lying on a wall (see pp. 68–9). Despite claiming 'I only deal with poverty. Always with gloom. You'll never see a joyous picture of mine', there is nonetheless humour in many of Lowry's observations of life. Here even the dogs stop at the waving red flag's signal, while a small boy rushes to get a closer look, followed by his father.

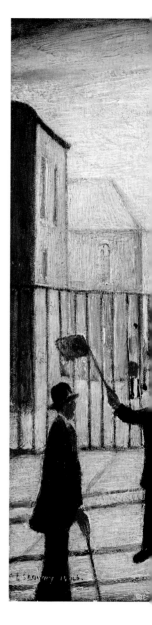

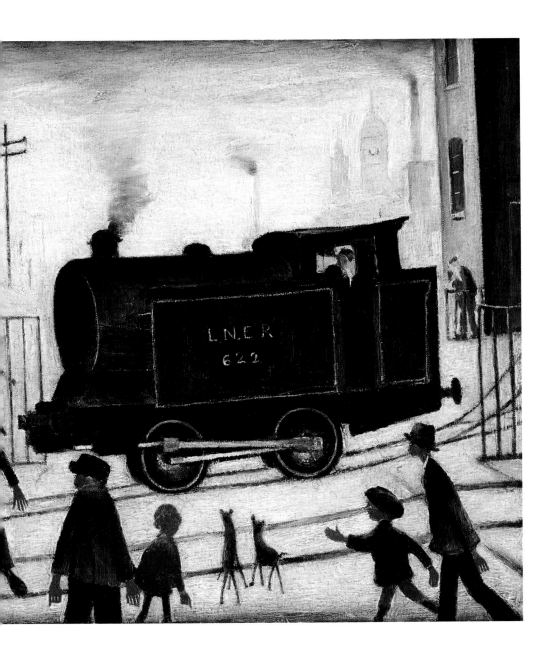

Laurence Stephen Lowry (1887–1976)

The Cripples, 1949

Oil on canvas, 76.3 x 101.8 cm

Purchased from Alex Reid & Lefevre Ltd in 1959

1959-641

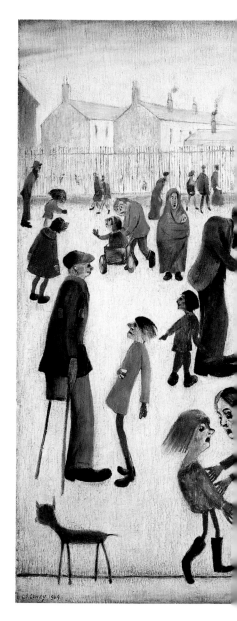

Painted only a few years after the end of the Second World War, the characters in *The Cripples* range from scarred war veterans to those marked simply by social deprivation. Lowry said that he had seen all of these people at one time or another and some were well-known characters around Manchester, including 'Johnny on the Boards' in the foreground on the right. In 1948 Lowry wrote to his friend, the artist David Carr, to say 'The Cripples picture is progressing – I have operated on one of the gentlemen in the far distance and given him a wooden leg ... I still laugh heartily at the hook on the arm of the [other] gentleman'. The apparent mocking, dark humour in this letter contrasts with other statements of Lowry's in which he felt that these later works represented his best period: 'I am saying more, going deeper into life than I did'. On another occasion he added 'I feel more strongly about these people than I ever did about the industrial scene ... There but for the grace of God go I'.

Elements of caricature and the grotesque come to the fore in many of Lowry's late pictures but these qualities had been present in his work from an early date. In some of his drawings from the 1920s, children turn towards the viewer with the faces of old men. 'There's a grotesque streak in me and I can't help it. My characters? They are all people you might see in a park ... They are real people, sad people ... I'm attracted to sadness, and there are some very sad things'. In Lowry's view there was a fine line between extreme grief and extreme sadness.

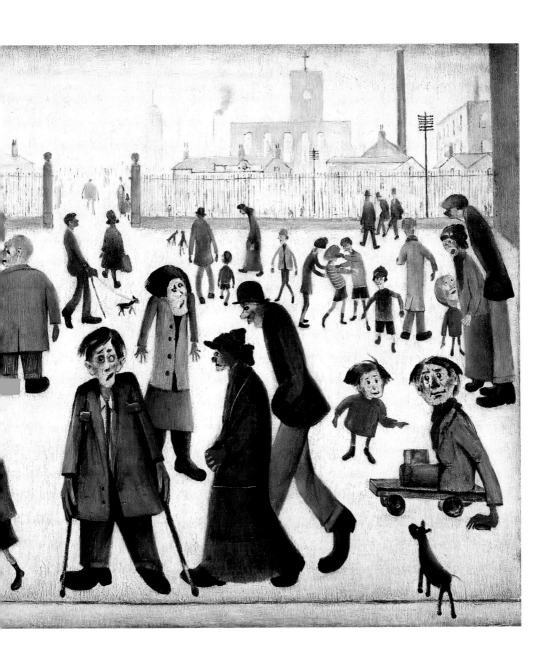

THE CRIPPLES | **61**

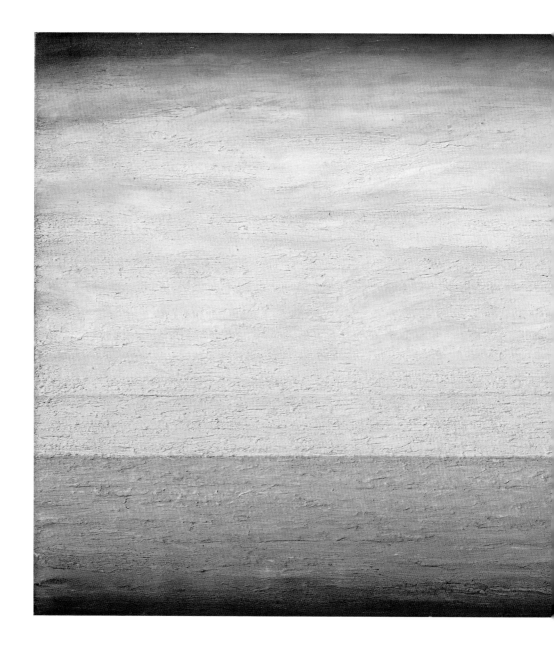

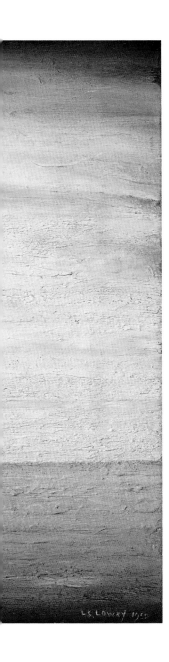

Laurence Stephen Lowry (1887–1976)

Seascape, 1952

Oil on canvas, 39.5 x 49.3 cm

Purchased from the artist in 1954

1954-152

Seascape was purchased by Salford Art Gallery for 54 guineas, the equivalent of around £1,650 today. This caused controversy at the time as some people questioned why so much public money was being spent on 'three lines of paint showing a beach without pebbles, a sea without waves and a sky without clouds, just because it was painted by LS Lowry' (in the words of Councillor Mrs Edith Parker). A response from the artist appeared in the *Manchester Evening Chronicle*: 'I never expected the picture to be very popular. It took me 18 months to paint and I think it is one of the best things I've done.'

The sea had been a constant source of inspiration for Lowry from childhood when he would draw yachts off the coast of North Wales or Lytham St Anne's on family holidays. After a trip to Anglesey in the 1940s he started to paint 'nothing but the sea … with no shore and nobody sailing on it'. By the 1960s he was repeatedly drawn to the North Sea and the view from the Seaburn Hotel in Sunderland, where he could watch the water's changing moods.

Lowry sometimes described painting these works as an escape, or relaxation, but he also described them as expressions of loneliness or as embodying the 'battle of life'. Despite the calm water their very emptiness can be unsettling, hinting at sinister undercurrents below:

> I have been fond of the sea all my life: how wonderful it is, yet how terrible … what if it suddenly changed its mind … If it didn't stop and came on and on and on and on and on … That would be the end of it all.

LAURENCE STEPHEN LOWRY (1887–1976)

The Funeral Party, 1953

Oil on canvas, 76.1 x 102 cm

Purchased from Alex Reid & Lefevre Ltd in 1959

1959-644

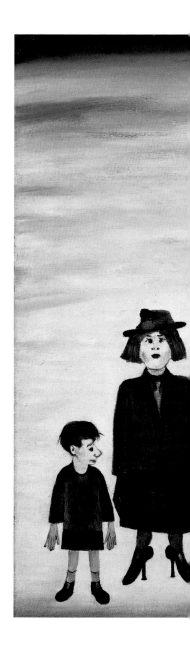

IN THIS ICONIC WORK a curious mixture of people stands alongside, but separated from, their neighbours in an unspecified space where sky and ground merge. Only the two children seem to acknowledge each other's presence. We don't know who has died, whether the funeral has already taken place or is about to begin. The atmosphere is tense, as though we are perpetually poised on the brink of some resolution that will make everything clear. Lowry's own explanation of the scene, playing up the dark humour, was simply to comment that the man on the far right of the painting was being treated as an outcast for having come to the funeral in a red tie and boots. There is a subtle range of colour in the sky but the painting's strength comes from its principal contrast of black and white.

Lowry had long been fascinated with cemeteries, churches – and death. As early as 1920 his small painting *The Funeral* showed a forlorn huddle of spectators at a burial in an otherwise empty churchyard, and in 1963 he declared 'I would really like to see my own funeral and paint it.' He spent decades before his death continually assuring friends of his ailing health and imminent demise.

Having retired from the Pall Mall Property Company the previous year, at the time of painting *The Funeral Party* Lowry's reputation had never been higher. By the end of the decade he would be a household name, thanks to several television documentaries, the first of which was broadcast for the BBC in 1957, and the circulation of limited edition prints after some of his paintings.

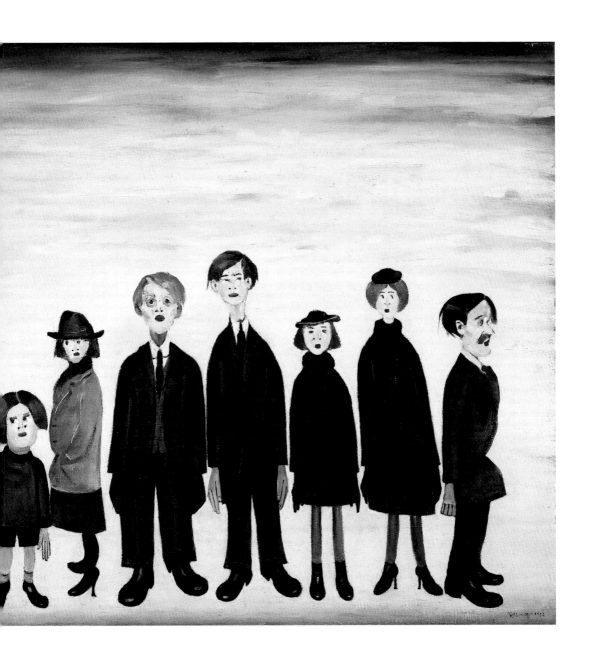

Laurence Stephen Lowry (1887–1976)

Francis Terrace, Salford, 1956

Pencil on paper, 25.3 x 34.9 cm

Purchased from the artist in 1957

1957-53

Francis Terrace, Salford was one of several drawings commissioned in the mid-1950s by Ted Frape, then curator of Salford Art Gallery. After the Second World War, bomb damage and the generally poor condition of many houses meant that many areas of Salford were earmarked for redevelopment. Frape wanted to record some of the streets near the Art Gallery before this happened.

Francis Terrace was not unusual in Salford in that it was a self-contained road, closed off from traffic, creating a stone-flagged courtyard area in front of the 'two-up, two-down' houses. A central drainage gutter ran the length of the street, which overlooked a similar row of terraced houses below. Although ostensibly making a topographical record of the area, Lowry replaced the roofline of the lower terraces with two tall chimneys and a factory roof.

The shared court was an area for children to play and residents to meet. In 1943 Lowry described one of his greatest pleasures as 'walking about the streets of any poor quarter of any place I may happen to be in'. He was well aware of the conditions in which many residents of Salford lived but he portrays this scene with affection, the child in the foreground holding tightly to the string lead of a toy dog while its real counterpart wanders freely on the stone flags behind. Francis Terrace was finally demolished in 1959.

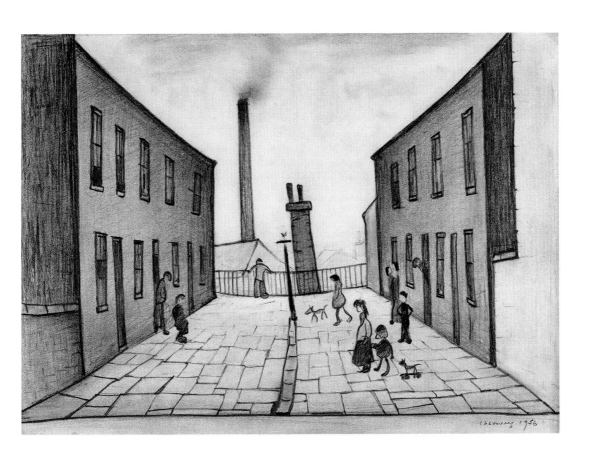

Laurence Stephen Lowry (1887–1976)

Man Lying on a Wall, 1957

Oil on canvas, 40.7 x 50.9 cm
Purchased from Alex Reid & Lefevre Ltd in 1959
1959·647

In the year he sold this painting Lowry commented:

> People ... refuse to believe me when I tell them I saw
> a man dressed just like that, doing just that, from the
> top of a bus at Haslingden [near Manchester]. It was
> the umbrella propped against the wall which caught
> my eye and prompted the picture ... The chap was
> well-dressed, obviously enjoying the smoke and his
> rest. I couldn't resist doing him as a subject.

This painting brings to the fore a wry observational
humour which Lowry accentuates by putting his own ini-
tials on the briefcase resting against the wall.

Lowry's work can range in tone from a bleak commen-
tary on humanity to the amused observation of its quirks
and frailties. Elements of caricature are present from an
early date, and many of his late drawings are populated by
almost surreal characters. *Man Lying on a Wall* is one of
Lowry's most straightforwardly humorous canvases and
it has become one of his best-known paintings. Like *The
Funeral Party* (see pp. 64–5), painted a few years earlier, it
appears almost monochromatic except for the warm pink
tones of the brick wall that is the dominant feature. The
sky is similarly rendered in subtle shades of pink, ochre
and grey. Lowry claimed that all his work was based on
what he had seen. 'Who are they Sir? They are my friends
and neighbours. Look along Stalybridge Road and you will
see every one of them – all done from life ... They are all
outside, every one of them – even the dog!'

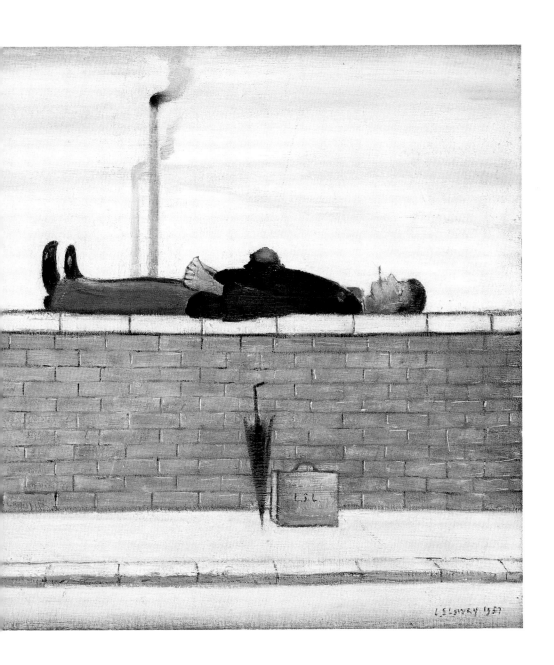

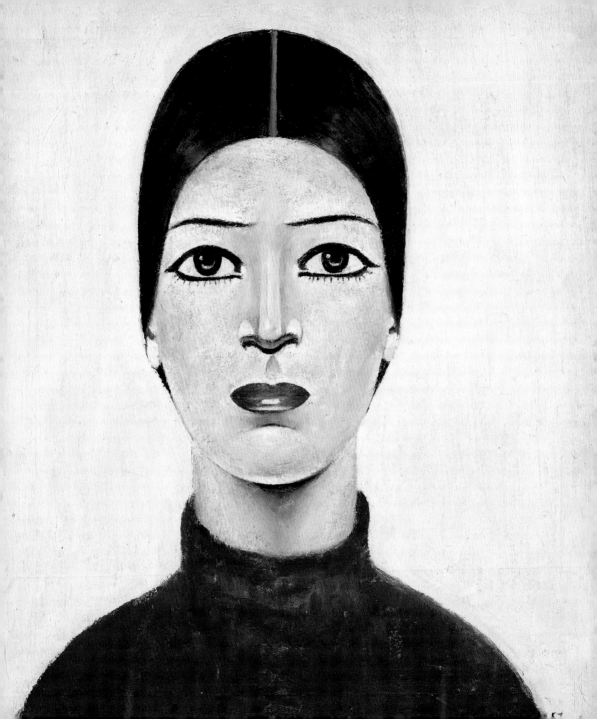

Laurence Stephen Lowry (1887–1976)

Portrait of Ann, 1957

Oil on board, 35.5 x 30.5 cm

Presented by the artist in 1960

1960-347

Lowry once described the sitter as aged 25, from Leeds and 'the daughter of some people who have been very good to me', but on other occasions he described her as his godchild Ann Hilder (or Helder) and gave various accounts of her background and family. No one has yet been able to confirm the identity of 'Ann'. Despite telling some friends that he would mention her in his will, her name does not appear there.

It seems more likely that Ann was an invented character, perhaps based on several friends such as the artists Pat Cooke and Sheila Fell, both of whom were dark haired with striking good looks. Ann's features – large dark eyes rimmed with black eyeliner, a severe central parting and full red lips – could equally have been based on more public figures such as Maria Callas or Margot Fonteyn (whom Lowry had seen perform with the Royal Ballet). She may also have been Lowry's own response to the idealised women drawn by the Pre-Raphaelite artist Dante Gabriel Rossetti. Lowry described Rossetti, along with Ford Madox Brown, as having been his favourite artist since he was a young man. After his retirement he began collecting the former's work in particular and owned several fine drawings of Rossetti's women.

When Lowry spoke of Ann to his friends they had no reason to doubt her existence, but none ever met her personally. Versions of her can be traced back to some of his earliest drawings in which a girl with a long plait recurs frequently. In this classic image, looking directly at the viewer, she is a rare female equivalent to Lowry's other portrait figures who were almost all men. Her gaze is calm and steady but she remains distant, her features mask-like and her expression unreadable.

LAURENCE STEPHEN LOWRY (1887–1976)

Yachts, 1959

Watercolour on paper, 26 x 36.2 cm

Purchased from the artist in 1959

1959-655

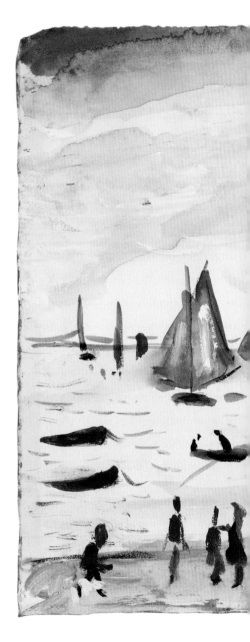

WATERCOLOURS ARE UNUSUAL IN Lowry's work and by his own estimation he painted only a few. All of them date from the 1950s when he borrowed a set of watercolour paints from a friend. His experiments with this medium were short-lived. 'They don't really suit me ... dry too quickly. They're not flexible enough. I like a medium you can work into, over a period of time'. His usual working method was to have a number of oil paintings underway at any one time, working on them in turn, often over several years, altering and improving. Attempting such alterations with watercolour simply muddied the quick-drying colours previously applied.

Pictures of sailing boats were, Lowry claimed, the only subject matter that his mother had liked, and he gave one or two away as gifts at family weddings. Towards the very end of his life a friend related that one of Lowry's last ideas for a new subject was to depict himself as a pillar in the sea, embattled and surrounded by crashing waves. He painted a small number of works on this theme before he died.

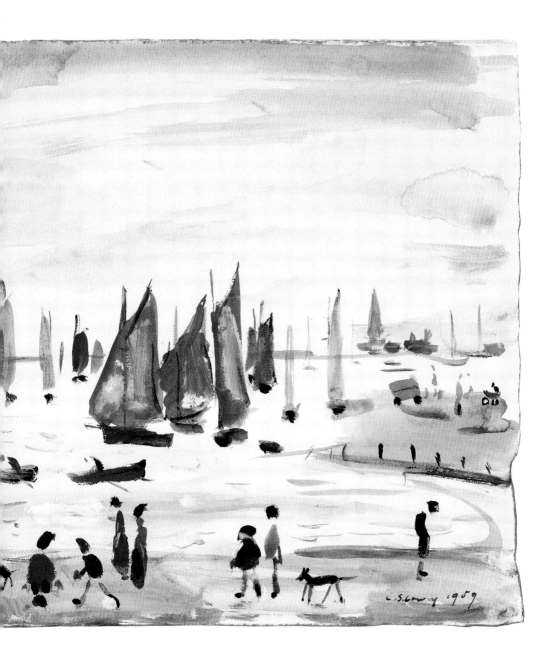

L.S.Lowry 1959

LAURENCE STEPHEN LOWRY (1887–1976)

Going to Work, 1959

Watercolour on paper, 27 x 38.5 cm
Purchased from the artist in 1959
1959-658

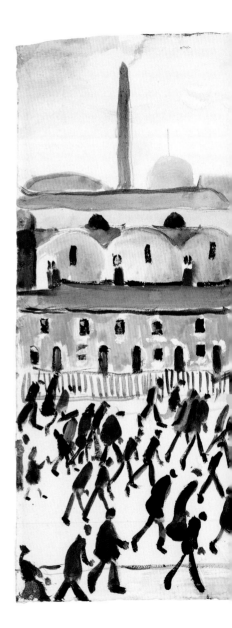

MOST OF THE WATERCOLOURS that Lowry painted were landscapes, but a few explored industrial subjects. This is probably the most successful and ambitious of those views and translates a classic scene of workers outside a mill building into fresh watercolour tones. The paper itself serves as an equivalent to the white ground that Lowry used for his oil paintings, resulting in bright, clear tones overall. By contrast, some of the landscapes he painted in watercolour are very subdued and don't fully exploit the possibilities of the medium.

By this date Lowry was tiring of the industrial scene as a subject, often wondering if he should have given it up in the 1940s. It took a trip to South Wales with his friend Monty Bloom in the 1950s to rekindle his interest. The mining towns of this region, set amongst hills and slag heaps, inspired a series of large canvases.

Although the urban landscape Lowry knew was changing beyond recognition by this time, he maintained that the people themselves had basically remained the same: 'they are all alone you know. They have all got their private sorrows, their own absorption … Crowds are the most lonely thing of all … You have only got to look at them to see that'.

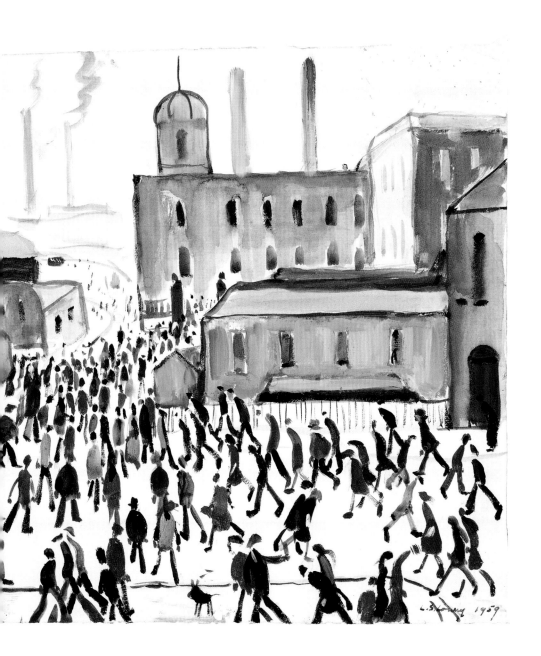

Laurence Stephen Lowry (1887–1976)

Gentleman Looking at Something, 1960

Oil on plywood, 24.5 x 10 cm
Purchased from the artist in 1961
1961-20

In Lowry's later works his focus changes from large gatherings of people to smaller groups or single figures, as though revisiting in detail some of the individual characters who had previously been lost in his crowds. Usually painted against a pure white background there is no indication of any architectural setting and a sense of place is hinted at by the barest minimum – often only a single horizontal line to indicate the edge of a pavement. Small in scale, Lowry often painted these works on pieces of board (sometimes the lids of cigar boxes, saved for him by friends for that purpose).

Although many of his subjects were people in the streets, down on their luck or homeless, this character is respectably dressed in a bowler hat and overcoat, staring at something unknown. Often Lowry's figures walk out of the picture entirely and are half-seen, leaving or arriving from a world beyond its margins.

Lowry never abandoned industrial pictures completely, but despite demand for them he felt he had largely exhausted the subject. 'I have done with the industrial scene. Finished with it. People still want me to do mill scenes with little people. Well, they must do without the little people'. The Stone Gallery in Newcastle, which did exhibit many of his later works, described them as being 'virtually unknown to the public at the time … it was almost like starting from scratch with an unknown painter'.

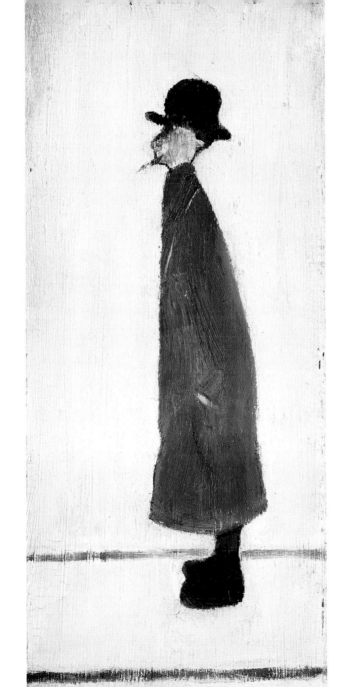

L.S.Lowry 1966

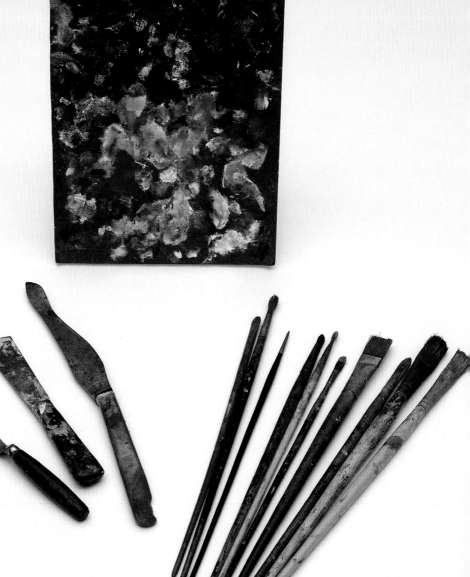

LAURENCE STEPHEN LOWRY (1887–1976)

Artist's materials belonging to L.S. Lowry

Donated by Harold Riley in 2000

ALONGSIDE THE WORKS OF art in The Lowry Collection there is an extensive archive of press cuttings, photographs, exhibition catalogues, correspondence and other items relating to Lowry's life and career. Among them are some of the artist's paintbrushes and other materials he used in his workroom.

When photographed or filmed painting, Lowry is seen using a traditional 'studio' or 'arm' palette. A similar piece of dark board to the one shown here can be seen in some photographs of Lowry's home, The Elms in Mottram-in-Longdendale, where he lived from 1948 onwards. Rather than being used to mix paint colours it may have simply been a surface on which to wipe off excess paint from his brushes. Not all of the knives he used were artist's palette knives, some were simply domestic knives with flexible blades, worn from long use.

Coming from the Mill (see pp. 40–1) was painted on Winsor and Newton's most expensive canvas but Lowry also worked on wooden panels, hardboard, plywood and cardboard. Occasionally he painted over existing works. For the most part he used five colours – ivory black, vermilion, Prussian blue, yellow ochre and flake white.

When drawing, Lowry often used his fingers or an eraser to soften hard lines and blend tones. Similarly, while painting he used not only brushes but rags, his fingers or knives to mix colours. Sharp objects, including the end of the paintbrush handle, were used to scratch into the paint surface. Sometimes he etched his signature onto a painting in this way. The old suits he wore as he worked became covered with paint marks from having brushes (and his fingers) wiped on them.

This edition © Scala Arts & Heritage Publishers Ltd, 2020
All artworks © The Lowry Collection, Salford
Text and photography © The Lowry 2020

All photography by Michael Pollard, except author portrait by
Mike Black Photographer and p. 5 photograph by Graham Finlayson

First published in 2020 by
Scala Arts & Heritage Publishers Ltd
10 Lion Yard
Tremadoc Road
London SW4 7NQ, United Kingdom
www.scalapublishers.com

In association with
The Lowry
Pier 8, The Quays
Salford M50 3AZ
United Kingdom
www.thelowry.com

ISBN 978-1-78551-323-7

Edited by Laura Fox
Designed by Matthew Wilson at Mexington.co.uk
Printed in Turkey

10 9 8 7 6 5 4 3 2 1

FRONT COVER:
Market Scene, Northern Town, 1939
(see pp. 54–5)

FRONTISPIECE:
The River Irwell at the Adelphi, 1924
(see pp. 22–3)

BACK COVER:
Self Portrait, 1925
(see pp. 28–9)